D0399204

EXPERIENCE OR INTERPRETATION

THE DILEMMA OF MUSEUMS OF MODERN ART

NICHOLAS SEROTA

THAMES AND HUDSON

ACKNOWLEDGMENTS

My awareness of the way in which the display of paintings and sculptures can influence our perception of them was kindled as a student by contact with Jim Ede's installation of his collection at Kettle's Yard, Cambridge. It was further developed through working alongside David Sylvester on the installation of an exhibition of Miró's sculpture at the Hayward Gallery in 1970 and in many subsequent conversations with him.

Naturally, the experience of collaborating with many artists on the presentation of their exhibitions at Oxford, Whitechapel and the Tate has profoundly influenced my thinking. I am grateful to them all, as I am to Teresa Gleadowe for her frequent insights and contribution to the development of this text.

May I also thank Michela Parkin and Lynn Murfitt, my colleagues at the Tate, for their assistance respectively on research and in the preparation of the typescript.

Any copy of this book issued by the publisher as a paperback is sold subject to the condition that it shall not by way of trade or otherwise be lent, resold, hired out or otherwise circulated without the publisher's prior consent in any form of binding or cover other than that in which it is published and without a similar condition including these words being imposed on a subsequent purchaser.

The Walter Neurath Memorial Lectures, up to 1992, were given at Birkbeck College, University of London, whose Governors and Master most generously sponsored them for twenty-four years.

© 1996 Nicholas Serota

First published in the United States of America in 1997 by Thames and Hudson Inc., 500 Fifth Avenue, New York, New York 10110

Library of Congress Catalog Card Number 96-61113
ISBN 0-500-55029-8

All Rights Reserved. No part of this publication may be reproduced or transmitted in any form or by any means, electronic or mechanical, including photocopy, recording or any other information storage and retrieval system, without prior permission in writing from the publisher.

Printed and bound in Italy

Like many others I have special reason to be grateful to Walter Neurath. At the age of eighteen, with a developing interest in modern art, I felt need of guidance and explanation. Thanks to Walter Neurath I did not have to look far. The World of Art series had recently begun to appear in bookshops. These volumes, containing original texts by some of the most eminent writers on art and an unusually high number of illustrations, were available at an almost affordable price, even for someone with many demands on his pocket. Perhaps with a sense that these books might become much thumbed companions I made the extravagant investment of 70 shillings in the hardback editions of Herbert Read's Concise History of Modern Painting *and* Concise History of Modern Sculpture. *Over the next ten years these two volumes were opened again and again.*

It was therefore an honour and a particular pleasure to be asked by Eva Neurath to deliver a lecture given in memory of her husband. Neurath's commitment to high-quality writing and reproduction and to making his books available to a general audience has profoundly encouraged appreciation of the visual arts. One consequence has been a rapid increase not only in the number, but also in the sophistication, of visitors to our museums. This lecture addresses the way in which museums devoted to modern art should attempt to serve Walter Neurath's general audience.

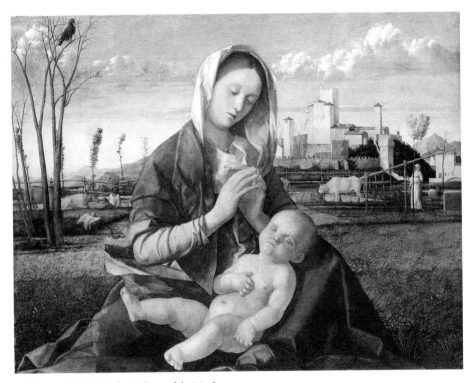

1 Giovanni Bellini, *The Madonna of the Meadow*, c. 1505

GIOVANNI BELLINI'S *The Madonna of the Meadow*, painted in Venice in about 1505, is one of the most affecting, serene and intimate images in the National Gallery. It was purchased for the Collection in 1858 by Sir Charles Eastlake at what we may now perceive as a critical moment in the development of the Gallery. Eastlake had been appointed Director in 1855.[1] In line with what had recently become continental practice and in fulfilment of the Gallery's purpose as a public institution with an educational role, Eastlake introduced a more rigorous historical framework for the Gallery. He broadened the scope of the Collection through the acquisition of works by early Renaissance painters. He adopted a policy of hanging by school and he sought to improve the way in which paintings were displayed.[2]

The acquisition of four Bellinis during Eastlake's period of office is just one reflection of his personal enthusiasm for early Italian painting.[3] By 1857 he was able to report to his Trustees, 'this room is now almost exclusively appropriated to works of the fifteenth century. Seventeen early Italian works are placed together and give a distinct character to the room, *illustrating* [my emphasis] the quattrocento schools of Italy.'[4]

The museum was becoming a history book rather than a cabinet of treasures. With regard to the display itself, Eastlake had advised the Trustees, 'It is not desirable to cover every blank space at any height, merely for the sake of clothing the walls and without reference to the size and quality of the picture.'[5] Although the single-line hang was not achieved at the National Gallery until 1887, the principle of historical grouping by school, with pictures hung at or slightly above eye level, often in aesthetically balanced groups, became the convention for display in most public galleries until the 1980s.

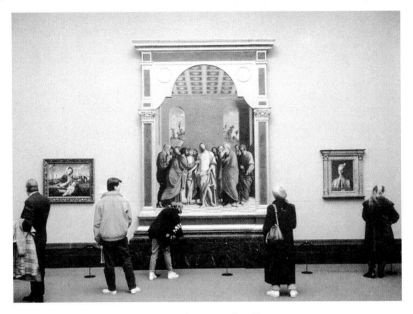

2 Thomas Struth, *National Gallery 1*, 1989

National Gallery 1 (1989), a photograph by the contemporary German artist Thomas Struth, contains by coincidence our *Madonna of the Meadow*, but also perfectly demonstrates the character of this historical and aesthetic display.[6] A devotional picture, an altarpiece and a portrait, painted by two artists working at a similar date, hang in a simple, almost symmetrical composition.[7] They are shown in a grand gallery, evenly illuminated from above by daylight flooding through roof lights or a laylight. The particular meaning, iconography or significance of each work may be explained through texts or labels placed close to the pictures or occasionally, though not here, by the careful juxtaposition of related compositions or themes. However, taken together, this group of pictures may be seen to 'illustrate', to use Eastlake's word, late quattrocento Venetian painting. As a visitor, one is conscious that grouping in this way places a curatorial *interpretation* on the works, establishing relationships that could not have existed in the minds of the makers of these objects, Bellini and Cima da Conegliano. This principle of interpretation, of combining works by different artists to give selective

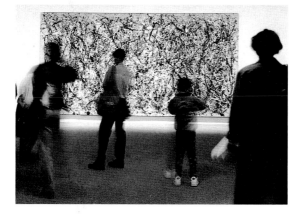

3 Thomas Struth, *Museum of Modern Art 1*, 1994

readings, both of art and of the history of art, is also one of the
fundamentals that has underwritten curatorial practice since the mid-
nineteenth century.

Another work by Thomas Struth, *Museum of Modern Art 1* (1994),
reveals a different approach to display. Struth's photograph shows us
Jackson Pollock's *One (Number 31 1950)* on view at the Museum of
Modern Art, New York, in the thoughtful new arrangement made in
1992 by Kirk Varnedoe, Director of Painting and Sculpture.[8]
Compared with the Beaux-Arts space lit by even, natural light found at
the National Gallery, this domestic-scaled room, with its relatively low
ceiling, is dark. The walls are illuminated by a wash of artificial light,
dramatizing the paintings and separating them from the space of
the spectator. The other walls in the room, not visible in Struth's
photograph, are similarly hung with slightly smaller paintings by
Pollock. For the visitor to the museum there are no distractions. The
control of space and light and the focus on a group of related paintings
serve to intensify the experience of Pollock's work, creating that hushed
transcendental mood which we associate with a chapel. It is an effect that
is reinforced as you turn to leave the room and see ahead of you an
antiphonal arrangement of Barnett Newman's paintings centred on *Vir
Heroicus Sublimus* (1950–51). If at the National Gallery and elsewhere we
may sometimes feel that we are attending lessons in the history of art, here

we are definitely out of school and at worship, with all our faculties given over to the experience of the work itself.[9]

As we move from the room containing Pollock to that containing Newman, this absolute concentration of focus on the work of single artists obliges us to develop our own reading of the work rather than relying on a curatorial interpretation of history.[10] Of course, Pollock and Newman belong to the same school, but as we encounter successive groups of work by single artists the story line becomes less significant and personal experience becomes paramount. As we shall see, the Museum of Modern Art is not alone in adopting this form of display. An increasing number of museums is following this model, prompting us to ask whether the museum is losing its fundamental didactic purpose. Clearly, if there is didactic purpose to such displays, it has a very different motive from Eastlake's highminded encyclopaedic history. And if we are simply looking at a group of works by a single artist we may perhaps enquire about the role of the curator, other than as a maker of mises-en-scène. My purpose, therefore, is to examine why such displays have become so prevalent and to ask whether they fulfil the requirements of the museum, before suggesting other models which may guide us in the future.

When Alfred Barr and his patrons established the Museum of Modern Art in New York in 1929, the mid-nineteenth-century principle of hanging by school gave way to a principle of hanging by movement.[11] Barr was exceptional in the breadth of his interests and during his initial period as Director the Museum collected widely in Europe and Latin America. But after the war the vision of the Museum narrowed. With few exceptions it was slow to respond to advanced American art and until the late 1950s continued to regard Paris as the fountain-head.[12] Nevertheless, the Museum of Modern Art, largely because of its exemplary early twentieth-century collection, the strength of its exhibition programme and the economic power of America, became the model to be followed by museums of modern art across the world. Well into the 1980s museums were continuing to build collections which aimed for complete representation of the major

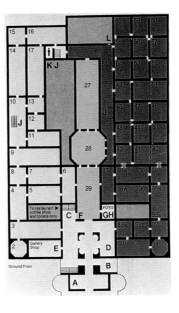

4 Ground plan of the Tate Gallery, London, 1979

movements hung in chronological sequence, though with less breadth of vision than the early Barr.

In 1981, the Tate Gallery explained its acquisitions policy over the previous thirty years in the following terms: 'what we have been trying to do is to form a collection which is both fine in quality and shows the richness and variety of modern art, with representation of all the major movements and with the greatest artists each represented by several works, or groups of works. The major purchases have been chosen not only on their own merits, but to add to the historical coherence of the collection as a whole; and for the first time visitors to the Tate can begin to see a panorama of twentieth-century art.'[13] In 1979 the Tate had celebrated the opening of a new extension with a display from the collection which aspired to be that panorama. The historical survey was densely hung in a sequence of square rooms, each of which represented the main movements of modern art. For the visitor the route is a labyrinth beginning with Impressionism, seen at the bottom of the plan, and ending in Minimal Art and Conceptual Art, seen at the centre.

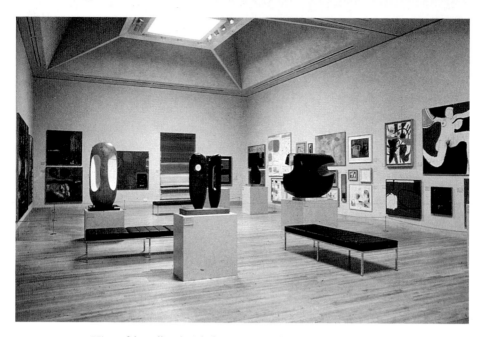

5 View of the gallery 'Nicholson, Hepworth, St Ives and British Nature Abstraction', Tate Gallery, London, 1979

The visitor travels along a single path with no byways and only occasional opportunities for exit. The sequence of small rooms is broken only twice in larger galleries devoted to aspects of the modern move-ment, 'International Abstraction up to 1939' and 'Nicholson, Hepworth, St Ives and British Nature Abstraction' presented in an installation that Eastlake might have characterized as 'clothing the walls'. Even areas of strength within the Tate Collection, such as Rothko or Giacometti, where concentrated experience of the works of art might be expected to take precedence, are presented primarily as further links in the chain of history.[14]

Five years later at the Museum of Modern Art itself, William Rubin, with rather greater resources at his command, adopted a remarkably similar approach in his presentation of the collection on the occasion of the reopening of the museum in much enlarged premises. The plan of the

second floor galleries shows another unbroken labyrinth passing from Post-Impressionism to Surrealism. Rubin's arrangement suggests that the flame of modern art burned only in two places and passed from Paris to New York at mid-century. Accordingly, very little art made outside Paris appears before 1940 and very little art made outside New York appears after 1950. German art, in particular, is poorly served, with Expressionism compressed into one small room. An artist of the stature of Beckmann, even though represented by a painting as important as *The Departure*, is squeezed out into the lobby. On the third floor of the museum, European art after 1950 was represented only by three artists, Bacon, Dubuffet and Giacometti.[15] None of the ecumenical character of Barr's approach remained. Reinforced by a policy of reframing all works in a single style of narrow gold or wood frames and in spite of exemplary groups of work by Matisse, Picasso, de Chirico and the Abstract Expressionists, the overall presentation of some of the great works and movements of the twentieth century was reduced to the form of a slide lecture.

In 1977 the creation of the Pompidou Centre in Paris sought to establish a new model for the interaction of creative disciplines in the twentieth century. The national museum of modern art was housed

6 Ground plan of the second-floor galleries, The Museum of Modern Art, New York, 1984

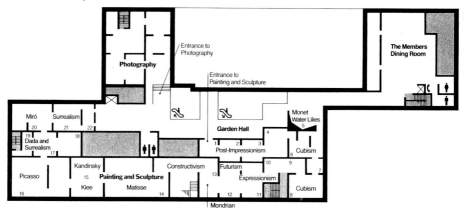

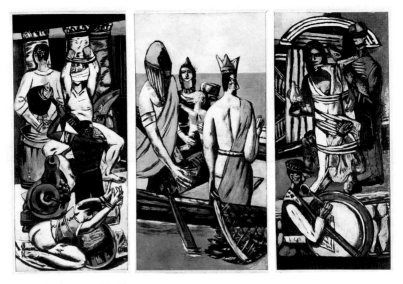

7 Max Beckmann, *The Departure*, 1932–33

alongside a centre for industrial creation, a public information library and a music centre. The programme reflected a culture still dominated by the events of 1968 and developed ideas pioneered by Willem Sandberg at the Stedelijk Museum, Amsterdam, over an eighteen-year period from 1945 to 1963.[16] In the place of the museum as monument Pontus Hulten proposed an 'open museum' which he described as 'not an anti-museum but a place where there is natural contact between artists and the public in developing the most contemporary elements of creativity. Such a museum is not simply a place to conserve works which have completely lost their individual, social, religious or public function but a place where artists meet their public and where the public themselves become creators.'[17] For Hulten the principal focus for the museum was therefore the exhibition conceived 'in a new spirit with a profusion of ideas and discovery', an ambition realized most brilliantly in his series *Paris–New York*, *Paris–Moscow*, *Paris–Berlin* and finally *Paris–Paris*.[18] A danger inherent in this emphasis on creativity and movement was that works of art in the permanent collection could

14

become almost incidental, as the photograph of the first exhibition may indicate. By 1985 Hulten's successor Dominique Bozo had felt obliged to create a series of rooms within the shell of the building to form interconnecting chambers laid out along a grand promenade.[19]

The evident limitation both of the labyrinth and of flexible space was one factor which encouraged a new form of display in the late 1980s. The Pollock display at the Museum of Modern Art is but one example of a much wider trend which within ten years has established a new, now even dominant convention for the presentation of twentieth-century and contemporary art. It is a convention which gives absolute weight to the work of individual artists, which favours presentation over analysis and which undermines the traditional priority given to the curator as the person who exercizes discriminating judgment over selection and display in the museum.

Examples of this new convention are now almost so common as to be taken as the norm. No one now remarks on the fact that the Tate regularly gives over a room to show the work of a single painter or sculptor, unless to praise or condemn the attention given to a particular artist. In the Kunsthaus Zurich we find rooms devoted to Picasso, Twombly, Beuys, Baselitz and, of course, Giacometti; in the

8 View of the exhibition *Paris–New York*, Pompidou Centre, Paris, 1977

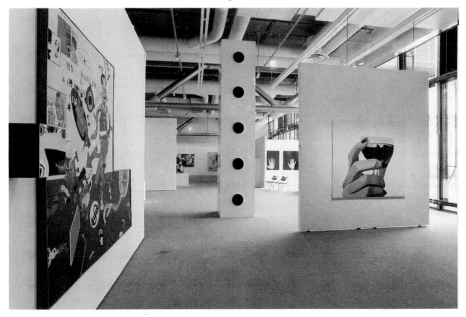

9 View of the gallery showing
late work by Barbara Hepworth,
Tate Gallery, London, 1992

Kunstmuseum Basel to Giacometti, Léger, Johns and, frequently, Nauman. At the opening of the new museum in San Francisco last year rooms or bays were similarly devoted to Polke and Kiefer. This style of collecting the work of living artists in depth and of displaying it in isolation is fast becoming the principal curatorial ambition for museums of modern art.[20] Two examples, one in America and the other in Europe, underline the trend.

In 1990 the Guggenheim Museum acquired a large part of the Panza Collection, gaining in one transaction ten or more works by, amongst others, Marden, Mangold, Nauman, Flavin, Andre, Judd and Serra. For many years Panza had shown this work in the converted stables attached to his villa at Varese in northern Italy.[21] In 1992, on the occasion of the reopening of the original Frank Lloyd Wright building and the expansion into new premises in SoHo, the museum chose not to display a complete cross-section of its collection. Instead, the main museum rotunda was given over to an installation by Dan Flavin, with complementary groups of work by Serra and contemporaries in the new

annexe and a very limited selection of major works in the secondary galleries around the rotunda. In the new extension in SoHo the whole space was given over to monographic displays of work by six artists presented in pairs, Ryman and Brancusi, Andre and Kandinsky, Bourgeois and Beuys.[22] The traditional museum disciplines of juxtaposition, analysis and interpretation were reduced to the minimum; experience was paramount.

As Thomas Krens has said in reference to the Guggenheim, 'I think the notion of encyclopaedia only makes sense in a world that is not mobile. I have tried to create an encyclopaedia by drawing upon big collections of artists' work where you can see a continuum in their development. To show that situation you need a lot of space.'[23] One can sympathize with this view, without accepting the solutions proposed by the Guggenheim — bulk installations by artists and international satellites across the world.[24]

In Bonn a new Kunstmuseum opened in 1993 in a building designed by Axel Schultes. Achieving quality of daylight in the galleries was

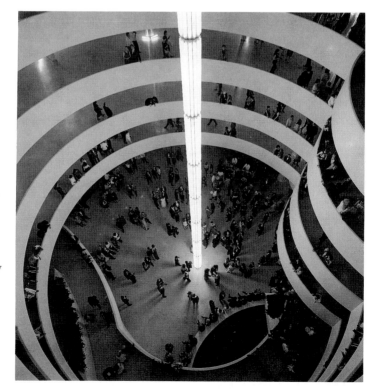

10 View of installation by Dan Flavin, Solomon R. Guggenheim Museum, New York, 1992

clearly paramount in the mind of the architect and director, although the rooms are laid out on a rather monotonous grid of squares and double squares. The collection of post-war German art is displayed spaciously according to the principle of one artist per room. However, notwithstanding its excellence in many respects, Bonn offers the visitor a sequence which provides cumulative impressions, but which makes no attempt to explore relationships between artists or to draw parallels between periods.[25]

Of course, in the past museums have occasionally presented concentrations or a cycle of works by a single artist. Charles Saatchi was not the first patron of this name to acquire substantial groups of work by a single artist, as is testified by the presence in the Royal Collection of the Raphael cartoons or Mantegna's *Triumphs of Caesar*. In the modern period some cycles or groups have also found their way into museums. Rothko's 'Seagram Murals', of which a selection is now housed at the Tate in an arrangement broadly determined by the artist, and the groups of paintings by Clyfford Still in the Albright-Knox Museum in Buffalo

11 View of a gallery showing work by Gerhard Richter at the Kunstmuseum, Bonn

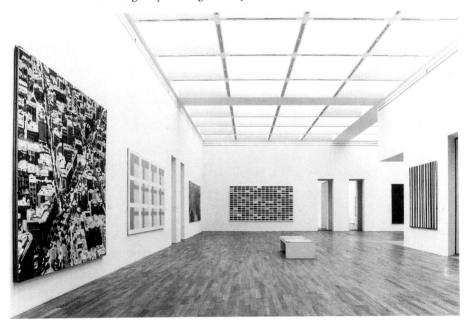

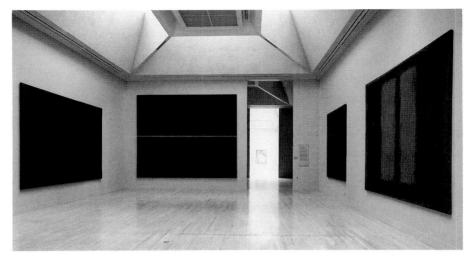

12 View of Mark Rothko's *Seagram Murals*, Tate Gallery, London, 1992

13 View of the exhibition of paintings by Clyfford Still at the Albright-Knox
Museum, Buffalo

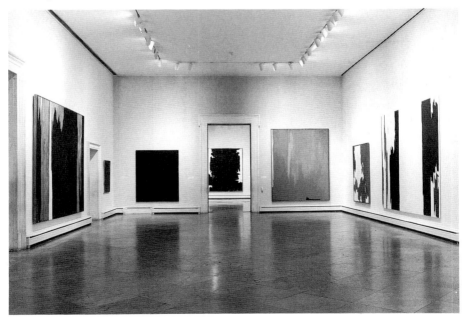

and in the San Francisco Museum of Modern Art are influential examples.[26] They also demonstrate the way in which artists themselves have made gifts of work and have thereby captured space within the museum which is separate from that of other artists and under the control of the maker rather than the curator.[27]

However, the factors which have encouraged this new form of monographic display are more profound than what some may argue is simply a tactic by artists wishing to secure their place in history. The manifestation which we observe at the Guggenheim or in Bonn may owe something to an increase in the size and scale of some contemporary art. It may, in part, be a reaction to a curatorial view which favoured a rather narrow, modernist interpretation of twentieth-century art in the period between 1960 and 1980. It may also have been encouraged by the increasing emphasis given to one-person exhibitions by living artists in commercial galleries and museums.[28] However, its ultimate origin lies, I believe, in three significant developments associated with the evolution of modern art during this century: firstly, a change in the relationship between the work of art and the space in which it is shown; secondly, the transfer by some artists of their place of work from the seclusion of the private studio to the public arena of the museum; and finally, an ever greater awareness by artists of the conventions of the museum itself. Each of these factors has contributed to a shift in the balance of the relationship between artist and curator.

It is, perhaps, in *The Red Studio* (1911) by Matisse that we can trace the beginning of a change in the way in which artists regard their own work and its place in the museum. This painting develops the theme of the model or the object depicted as a subject within the artist's studio. It was a theme which had appeared much earlier in Matisse's work and one to which he would return again and again. Here, however, the absence of the painter or his model is striking. As in *The Pink Studio*, completed earlier in the same year, the subject is the artist's own working environment, his own paintings and sculptures disposed in an arrangement around the room.[29] In *The Red Studio* the corner offers no exterior view, but encloses the space in which the artist self-consciously

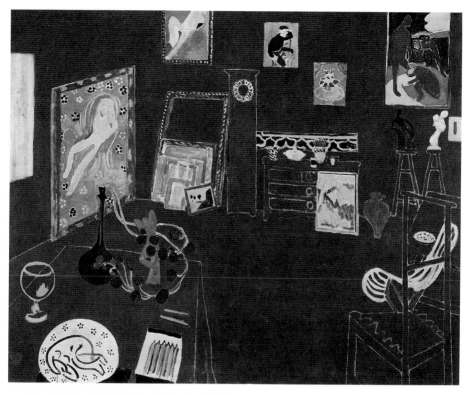

14 Henri Matisse, *The Red Studio*, Issy-les-Moulineaux, 1911

explores the relationship between his own works and their setting. This was a new subject for the artist. Earlier depictions of the studio had been of a more conventional kind showing the artist or his pupils at work or had focused on the artist himself, as in the eloquent portrait by Géricault of an artist friend. Courbet's allegorical *L'Atelier* (The Artist's Studio) had broken with such conventions but had employed the studio as a stage on which to set actors in a grand morality play. By contrast the studio pictures of Matisse look forward to his decorative schemes of the last years in which the artist takes control of space and manipulates an environment through the use of colour and light, as we may see in photographs taken in the studio at the Hôtel Régina, Nice, showing

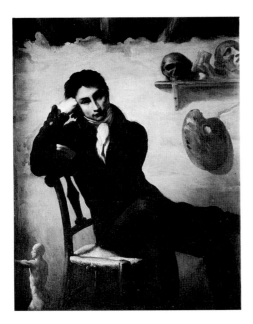

15 Théodore Géricault,
Portrait of an Artist, c. 1820

16 Gustave Courbet, *The
Artist's Studio,* 1854–55

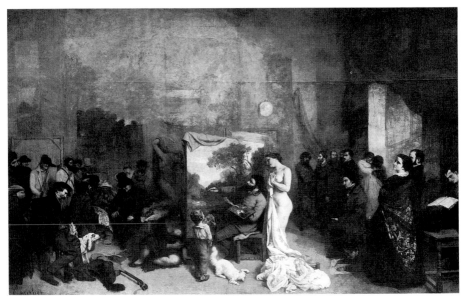

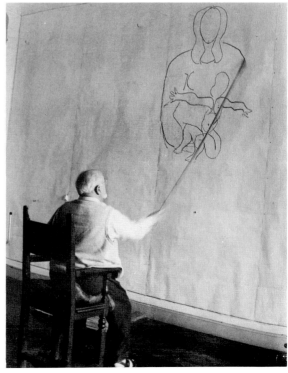

17 Photograph by Hélène Adant of Matisse's studio at the Hôtel Régina, Nice, showing his work *La Piscine* (The Swimming Pool), *c.* 1952

18 Photograph by Hélène Adant of Matisse's studio at the Hôtel Régina, Nice, showing the artist drawing the Virgin and Child for the Chapel of the Rosary, Vence, 1950

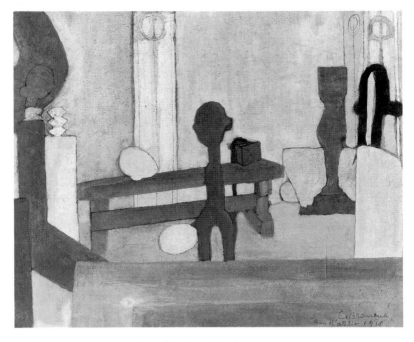

19 Constantin Brancusi, *View of the Artist's Studio*, 1918

La Piscine (The Swimming Pool) and the artist at work on his composition for the Chapel at Vence.

The Red Studio and the views of Matisse at work show an artist exploring the relationship between real and fictive worlds. For Brancusi, however, the studio became both the workshop and the place of display. A gouache of the studio in about 1918 is evidence of a life-long obsession with the placing of sculpture in a room and with the interrelationship of works with space.[30] A photograph taken by Brancusi in the studio at about the same date is an early example of his intensive use of the camera to record his own work in the studio in different configurations and under different conditions of light. Brancusi's photographs record how he explored the use of dark as well as light backgrounds to give different degrees of reflectance for his sculptures. However, two photographs of the same corner, the first taken in about 1925 and the second in about 1945–46, show how he also progressively modified the studio, blocking

24

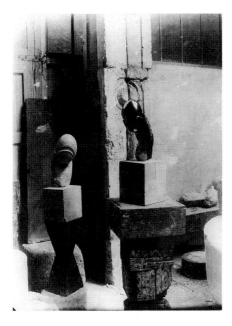

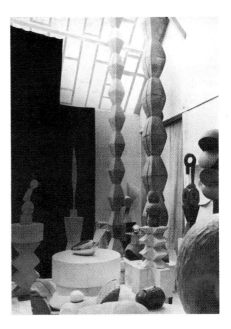

20 Photograph by Constantin Brancusi of his studio, showing *Mlle Pogany II*, c. 1920

21 Photograph by Constantin Brancusi of his studio, showing an *Endless Column*, c. 1929

22 Photograph by Constantin Brancusi of his studio, showing an *Endless Column*, *Fish* and *The Sorceress*, c. 1925

23 Photograph by Constantin Brancusi of his studio, showing *King of Kings*, c. 1945–46

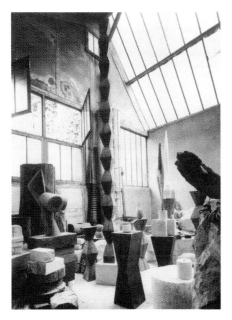

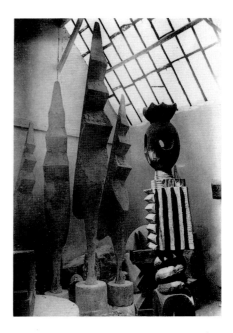

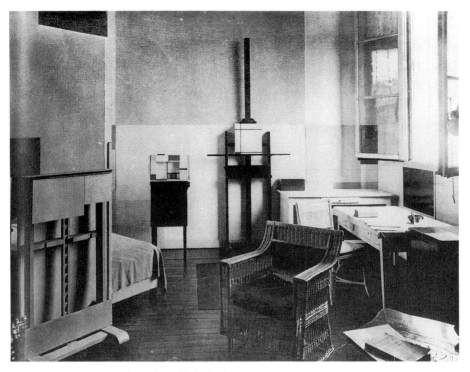

24 Piet Mondrian's studio in Paris, 1926

the window by building a wall, to give a greater sense of enclosure and separation from the outside world.

Brancusi's singular sensitivity to the placing of works of art in changing environments has had a profound impact on the course of sculpture and on the display of art in the twentieth century. This influence was achieved in part by his decision to bequeath the contents of his studio to the French nation on the condition that the studio itself was reconstructed at the Musée de l'Art Moderne.[31] For more than thirty years it has made a lasting impression on successive generations of visiting sculptors.[32]

If Brancusi and his studio have exerted a profound influence over sculptors, Mondrian's parallel obsession with the proportions and space

26

of his working environment has provided an equivalent inspiration for painters. His successive manipulations of the studio in Paris and later New York have entered the consciousness of painters and curators through frequent publication. Mondrian's exploration of the effects of planes of colour, not only on the flat surface of the wall, but also within the three-dimensional space, established a new level of awareness of the wall as a support for painting and a more thorough involvement with the control of space within the room. In an essay published in *De Stijl* in 1919–20 in the form of a trialogue, Mondrian sets one scene in the studio of an abstract painter who defines the qualities of a room as follows: 'To give us continuous aesthetic satisfaction the room has to be more than an empty space bounded by six empty planes facing one another: it must be articulated and therefore a partially filled space bounded by six articulated planes that oppose one another by their position, dimension and colour.'[33] And in his proposal for an international museum of contemporary art in 1931, he writes: 'This series of galleries [should] be followed by a room in which painting and sculpture will be realized by the interior itself.'[34]

Since the 1920s artists have created environments which establish independent space to be entered by the viewer, rather than simply modifying the space which is given by the museum. Lissitsky's *Proun*

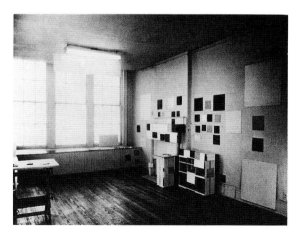

25 Photograph by Harry Holtzman of Piet Mondrian's studio in New York, 1944

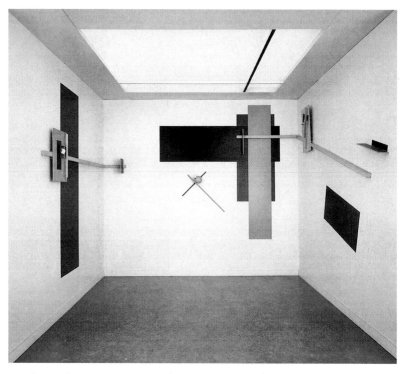

26 El Lissitsky, *Proun Room*, 1923 (1965 reconstruction)

Room, or Schwitters' successive versions of the *Merzbau*, are indicative both of a certain frustration at the limitations of painting as the sole means of controlling space and of a wish to develop a new kind of relationship between the object and the viewer. Neither artist was content that painting should be confined to representation, or even abstract decoration for an existing room. It had to occupy a three-dimensional space.

However, the world created by the artist may also be entered psychologically rather than physically, as in Marcel Duchamp's *Etant donnés*. Constructed over a twenty-year period and completed shortly before his death in 1968, this work is now installed permanently, according to the artist's wish, as the culmination of a group of his works

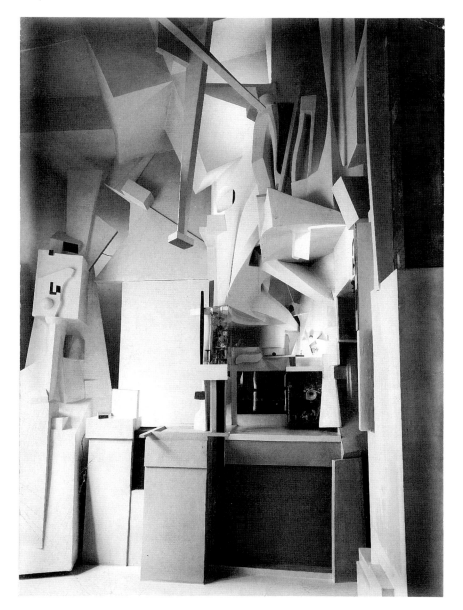

27 Kurt Schwitters, *Merzbau*, completed in Hanover 1933

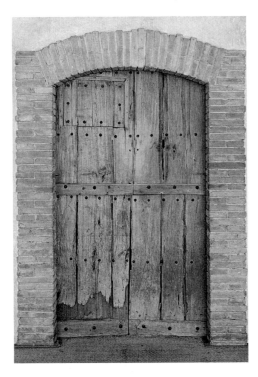

28 Marcel Duchamp, *Etant donnés: The Waterfall*, 1946–66

in the Philadelphia Museum of Art. The viewer enters a small room and approaches an old wooden Spanish door, framed in a brick archway set within a plaster wall. He looks through the two holes set at eye-level in the door. The viewer, now voyeur, sees a brilliantly lit landscape in which a waterfall plays in the distance. A naked figure of a woman lies with her legs apart on a bed of brushwood holding in her left hand a dimly illuminated gas-lamp. The tableau is at once secret, shocking and enigmatic, with the face of the figure hidden from view by her flowing blond hair. A sense of complicity is established between the artist and the single viewer, a collusion excluding all other visitors.[35]

Matisse, Brancusi, Mondrian, Lissitsky, Schwitters and Duchamp, artists of two closely interrelated generations, established new boundaries in a manipulation of plastic space and new parameters for the

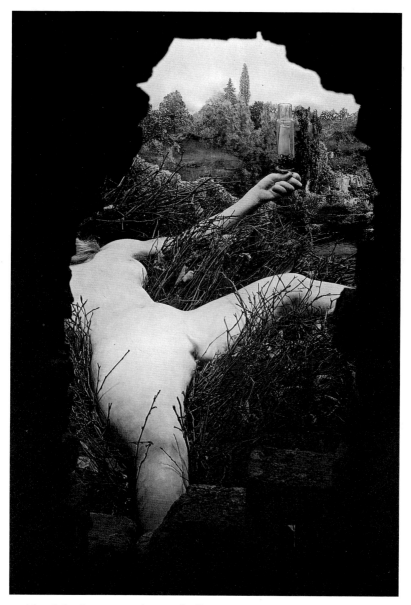

29 Marcel Duchamp, *Etant donnés: The Illuminating Gas*, 1946–66

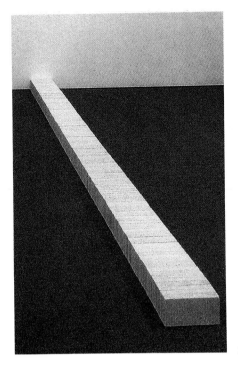

30 Carl Andre, *Lever*, 1966

31 Carl Andre, *Seventeenth Copper Cardinal*, 1977

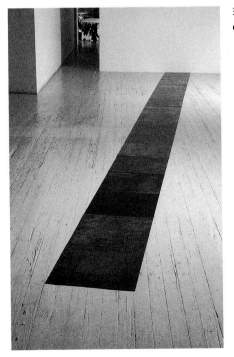

relationship between the viewer and the object. However, in terms of the impact on museum practice even more decisive steps were taken by a generation of artists working in the 1960s.

Carl Andre has described the evolution of sculpture in the twentieth century as a change of interest from 'sculpture as form' to 'sculpture as structure' and finally 'sculpture as place'. In works like *Lever* (1966), or in his series of 'Copper Cardinals', Andre himself has consistently engaged with and invaded the space of the viewer. Even more radically, he has occasionally absorbed a given space into the work itself, as in *Eight Cuts* (1967), in which the removal of sand-lime bricks from the floor creates voids within the volume of the room.[36]

That direct engagement with the space may be compared with a slightly later work by Richard Serra. *Splashing* is a sculpture which has frequently been compared with Pollock's gestural paintings on account of its shared dependence on the physical throwing of paint or lead, and the sense in which the work is the evidence of earlier performance; and

32 Carl Andre, *Eight Cuts*, 1967

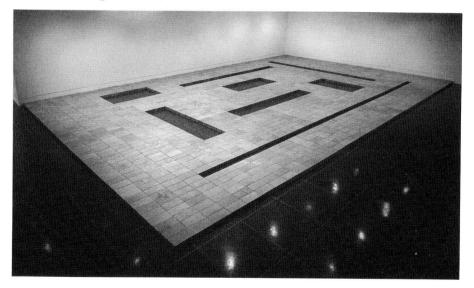

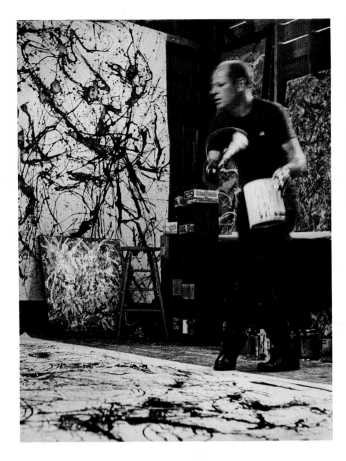

33 Photograph by Hans
Namuth of Jackson
Pollock painting in his
studio, East Hampton,
Long Island, *c.* 1950

34 Photograph by
Gianfranco Gorgoni
of Richard Serra
throwing lead, Castelli
Warehouse, New York,
1969

35 Richard Serra,
Splashing, 1968

because of Serra's known admiration of Pollock's work at this particular
moment.[37] There is a telling similarity between Namuth's images of
Pollock and those by Gorgoni showing a masked Serra in action at the
Castelli warehouse.[38] The form and reading of Serra's sculpture, like
Andre's, is given by the place in which it is installed. Also like Andre,
who returned the bricks to the supplier after the exhibition, the work
only exists for the duration of its installation. *Splashing* is successively
realized and destroyed in each of the locations in which it is shown. Serra
has continued to develop sculpture and drawing in which form and scale

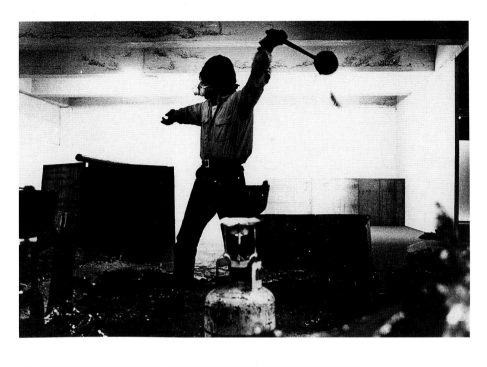

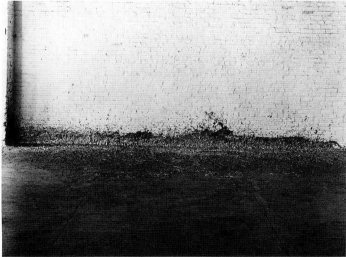

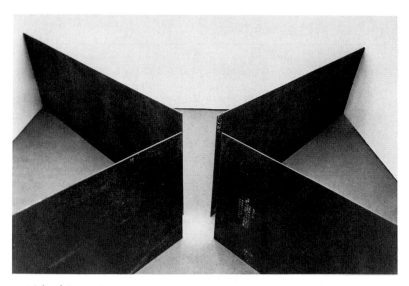

36 Richard Serra, *Circuit*, 1972

are profoundly influenced by the specifics of the site in which the work is located. *Circuit* (1972), four equal plates standing in the corners of a square room, both defines and cuts into space. In *Weight and Measure* (1992) the mass of the two differently sized blocks is calculated to balance the volume of the Duveen galleries at the Tate.[39]

These works also share a feature which has come to characterize the work of many artists of their generation: the sculptures were realized in the place of exhibition itself. The gallery or museum has become a studio, prompting a significant change in the conventional relationship between the artist, the work of art and the curator. No longer can the curator be seen solely as the dispassionate judge of quality, who visits the studio or private collection to select works and to assemble a body of material which will be presented to the public in the museum. Instead the curator is a collaborator, often engaging with the artist to accomplish the work.

The rapidly increasing involvement by some artists in the physical space of the museum has been matched by a heightened engagement by

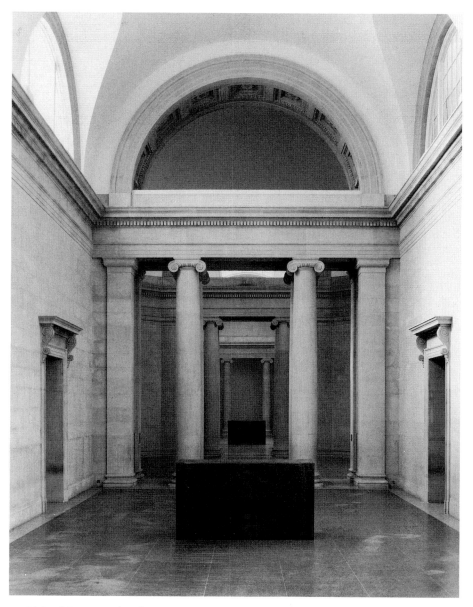

37 Richard Serra, *Weight and Measure*, 1992

other artists with the taxonomies and history of the museum itself. The Surrealists had exposed and challenged some of the prevailing conditions by bringing together contemporary work with objects from earlier cultures. In the late 1960s a number of European artists began to examine what Marcel Broodthaers called 'the fiction of the museum'. In 1968 he opened a museum in his town house in Brussels which he called 'Museum of Modern Art, Department of Eagles, Nineteenth-Century Section'. In subsequent manifestations he added sections devoted to literature, finance, the cinema and publicity. In 1972, at the Kunsthalle in Düsseldorf he added 'Section of Figures (the Eagle from the Oligocene to the Present)'. Broodthaers' museum fiction is both a homage to and a parody of the traditional museum. In Düsseldorf he assembled three hundred objects containing eagles drawn from many cultures borrowed from museums and private collections across the world. They were shown in traditional museum vitrines and each was

38 View of Marcel Broodthaers's exhibition *Section of Figures (the Eagle from the Oligocene to the Present)*, Kunsthalle, Düsseldorf, 1972

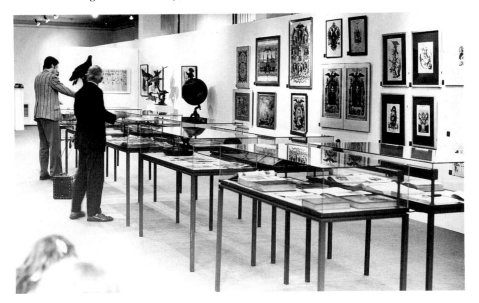

39 Detail from Marcel
Broodthaers's exhibition
*Section of Figures (the Eagle
from the Oligocene to the Present)*,
Kunsthalle, Düsseldorf, 1972

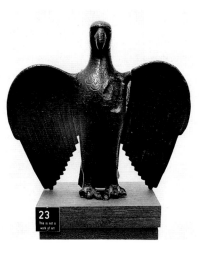

accompanied by a Magrittean label, 'This is not a work of art.' The artist
himself exposes and subverts the traditional classifications and habits of
the museum.

I have been exploring three themes: the cumulative power of an
assembly of the works of a single artist, especially in a presentation
determined by the creator; the control of museum space by the artist; and
finally the artist reflecting on the conventions of the museum. These
themes are drawn together in one manifestation at the Hessiches
Landesmuseum in Darmstadt: the Beuys Block.

The Block was assembled by the collector Karl Stroher through
purchases from several Beuys exhibitions in the late 1960s. Installed
by Beuys himself in a sequence of seven rooms, the Block contains
sculptures, drawings, multiples and objects remaining from actions or
performances. The display is housed on the top floor of the museum. In
side rooms Beuys adopts the conventions of the geological or natural
history museum rather than the gallery. He assembles a lexicon of objects
displayed in vitrines drawn from the museum store. The classifications
are his own, as is the placing of vitrines within each room, according to
the principle of sculptural intervention rather than museum order.[40] The
sequence is carefully choreographed from an entrance gallery, containing

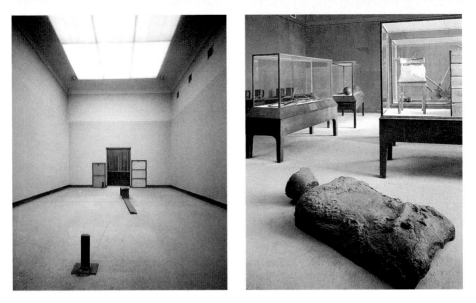

40 Room 1, Beuys Block, Hessisches Landesmuseum, Darmstadt

41 Room 3, Beuys Block, Hessisches Landesmuseum, Darmstadt

only two works, through the second room, containing a group of sculptures dealing with the creation of energy and its transmission, to the smaller rooms of vitrines, containing objects which have survived from earlier performances to form a dictionary of actions. Between them lies a room of intermediate size containing cast bronze and other sculptures of medium scale shown in nineteenth-century wood and glass vitrines.

Beuys controls the experience from the moment of entry to the large room through the passage to ever-smaller chambers. Each room, with its dense carpet and now darkening hessian-clad walls, is acoustically soft, a cocoon in which the spectator may discover treasures, just as a child might when visiting a museum of specimens. Beuys must also have been conscious that he was placing some of his major works in a relatively small and remote town, albeit one with an historic past. No one now travelling to Darmstadt can remain untouched by the sense of pilgrimage involved in the journey to the town and in the climb to the upper floor

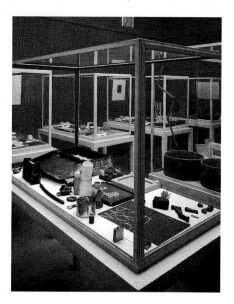

42 Room 5, Beuys Block,
Hessisches Landesmuseum,
Darmstadt

43 Room 2, Beuys Block,
Hessisches Landesmuseum,
Darmstadt

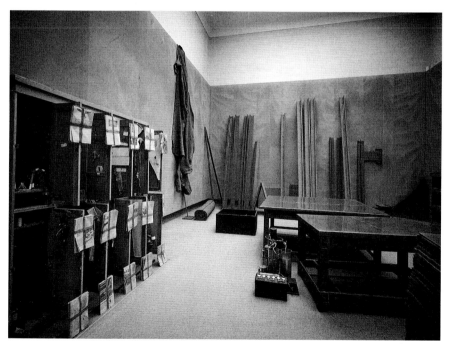

of the museum. Like the Matisse chapel in Vence, the Rothko chapel in Houston, the Brancusi studio in Paris or the Duchamp rooms in Philadelphia, Darmstadt is a self-contained visit, a shrine which prompts absolute focus of concentration.

We have been looking at the way in which changes in the nature of art and in the ambition of artists have affected the character of museums and the balance between artist and curator. I have argued that in the 1980s the historical interpretive hang has frequently been replaced by a display which favours presentation of single artists' work seen in depth and isolation. I have criticized the narrow view evident in displays inspired exclusively by a modernist canonical reading of the twentieth century, but I have also suggested, taking as examples the Guggenheim in New York or the Kunstmuseum in Bonn, that a sequence of single-artist displays is not the complete answer. This brings us to the issue implicit in the question raised by the title of this lecture. What do we expect from museums of modern art at the end of the twentieth century?

We may agree that the encyclopaedic and dictionary functions of the museum are neither achievable nor desirable. But there is less general agreement on how to balance the interests of the artist, the curator and the visitor. Some of the larger institutions have begun to explore new approaches. They have become more selective in their acquisitions, creating areas of strength, as at the Guggenheim. They have invited artists to create new readings of their collections, as in Scott Burton's short-lived 1989 installation of the Brancusi collection at the Museum of Modern Art, or more controversially, as in Joseph Kosuth's selection of works from the collection of the Brooklyn Museum.[41] However, the most stimulating developments have occurred in smaller museums, where the sense of institutional responsibility towards conventional expectations is less pressing.

One influential model is the Hallen für Neue Kunst in Schaffhausen, Switzerland. The institution occupies three floors of a former textile factory which is lit by windows on both sides. The open floors are divided into a sequence of spaces rather than chambers, as in the permanent installation by Beuys of *Das Kapital*. Artists are generally

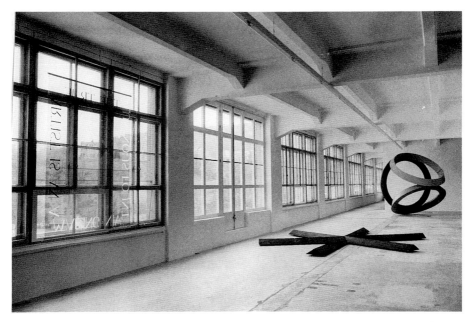

44 View of three works by Bruce Nauman, Hallen für Neue Kunst, Schaffhausen, Switzerland

45 Joseph Beuys, *Das Kapital Room*, 1970–77, Hallen für Neue Kunst, Schaffhausen, Switzerland

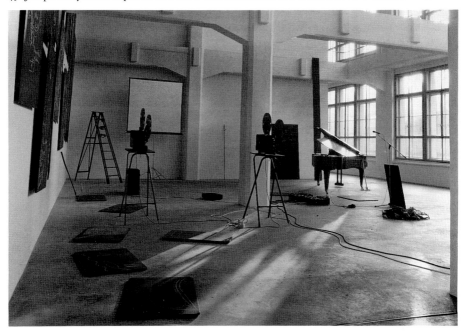

46 View of gallery with Carl
Andre's *Thirty-Seven Pieces of
Work* (left) and *Sum 13* (right)
with paintings by Robert
Ryman, Hallen für Neue
Kunst, Schaffhausen,
Switzerland

represented by several works presented as clusters, which has the effect
of creating overlapping and merging zones of influence. As a result
unexpected readings and comparisons occur. In Robert Ryman's
paintings the spectator's pleasure at reading modifications of surface,
from warm to cool or from refined to expressive, is heightened by the close
juxtaposition of his work with Carl Andre's sculpture *Thirty-Seven*

44

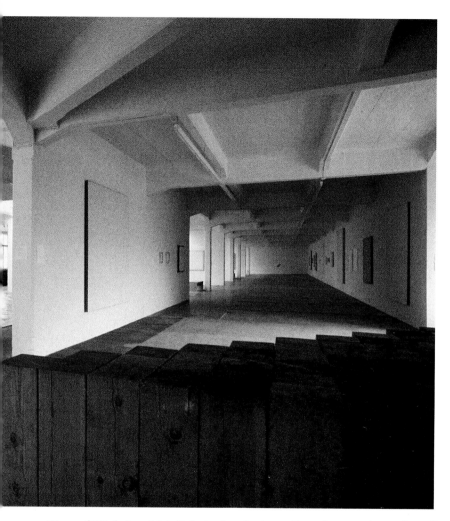

Pieces of Work, in which light is absorbed or reflected across the surface of six different metals. Such subtleties should be one ambition of the museum of modern art.

Schaffhausen draws together artists of approximately the same generation and of related sensibilities. Greater daring is present at the Insel Hombroich, an isolated private museum established by Karl Heinz

45

Müller on a wasteland at Neuss outside Düsseldorf.[42] Müller houses his collection in a series of pavilions constructed according to the designs of the sculptor Erwin Heerich. These are strikingly simple but offer considerable variety, with rectangular and square rooms, and even some asymmetrical, of different heights and proportions arranged in contrasting plans. Each has its singular quality of light and volume. Müller adds to this complexity by showing work from earlier cultures alongside contemporary art, as in the installation of Khmer sculptures and abstract paintings by Gotthard Graubner, and by making surprising comparisons, as in the display devoted to Fautrier and Corinth, both represented by exemplary groups of works.

Such juxtapositions are perhaps a more natural strategy for the private collector, or for the exhibition maker, than for the museum curator. In recent years exhibitions and displays have been presented according to this dialectical principle with increasing frequency. The main room in

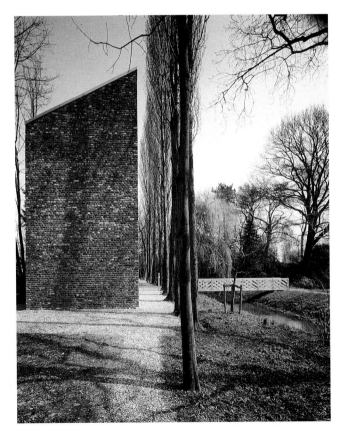

47 Insel Hombroich, Neuss, Germany

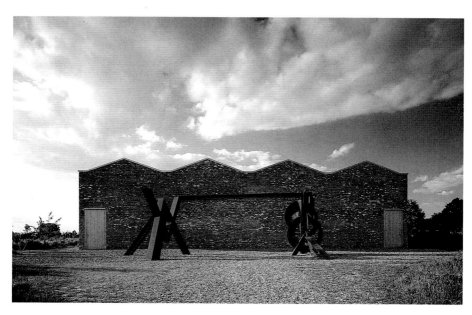

48 View of Insel Hombroich, Neuss, Germany, with sculpture by Marc di Suvero

49 Ground plan of the pavilions of Insel Hombroich, Neuss, Germany

50 *Following pages*: view of the gallery with Khmer sculptures and paintings by Gotthard Graubner, Insel Hombroich, Neuss, Germany

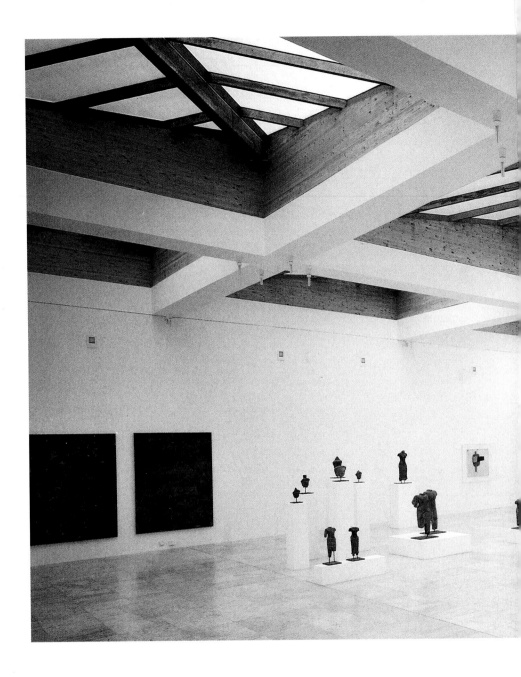

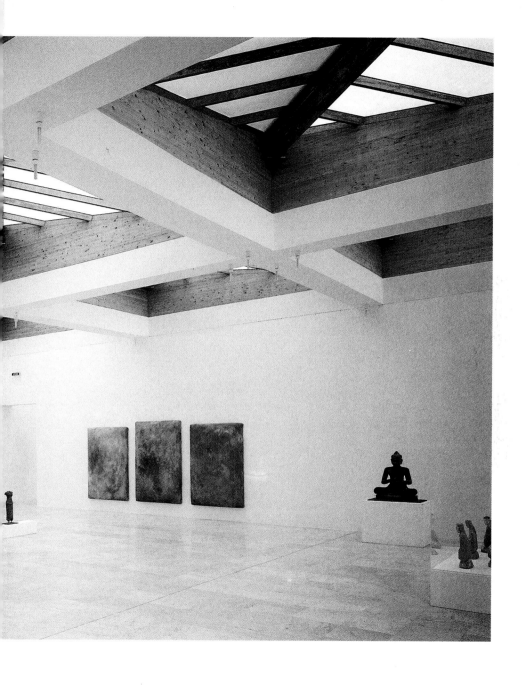

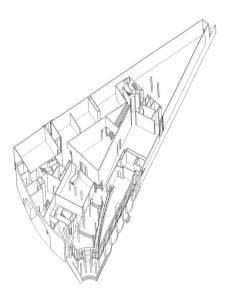

51 Ground plan of the first floor of
the Museum für Moderne Kunst,
Frankfurt-am-Main

52 View of the central room,
Museum für Moderne Kunst,
Frankfurt-am-Main

the exhibition *A New Spirit in Painting* at the Royal Academy in 1981
brought together three artists of two generations, Balthus, de Kooning
and Baselitz, in an assembly which disclosed unexpected parallels and
contrasts between three contemporary approaches to the figure.

A comparable strategy, devised by Rudi Fuchs for *documenta 7* in
Kassel in 1982, was subsequently introduced to the museum at Castello
di Rivoli outside Turin in 1984, and more recently in a series of so-called
'Couplet' exhibitions at the Stedelijk Museum in Amsterdam.[43]
According to the Fuchs principle, works by a single artist are dispersed
to different parts of the exhibition or museum. Works by Baselitz, for
instance, might be seen initially alongside Beuys, then alongside
Chamberlain. On each encounter another aspect of the work is
emphasized. At best this broadens and complicates the spectator's
understanding of the work, though for some viewers these juxtapositions
can sometimes appear perverse or obscure.[44]

I have been suggesting that a willingness to engage in personal
interpretation, to risk offence by unexpected confrontation, can yield
rewards. Nowhere is this curatorial courage more evident than at the

new Museum für Moderne Kunst in Frankfurt. From unpromising beginnings, Jean-Christophe Ammann has created a dynamic and often challenging view of the art of the 1960s and 1990s. The building by Hans Hollein occupies a wedge-shaped plot and was completed in 1991. Hollein resolved some of the awkward geometries of the site by grouping his galleries on three floors around the high central room. This gives a point of orientation and allows the architect to play with staircases and levels. But it remains a difficult building in which to install art. Ammann has responded with wit, inviting artists to occupy spaces designated as service spaces. Fischli and Weiss, for instance, have installed a work under the stairs, and a work by Boltanski is shown in what was to have been a store cupboard. Ammann works, as he says, 'from the perspective of my mind's eye'[45] and has sought to bring appropriate works into rooms with a particular character, as in a triangular room containing a sculpture by Katharina Fritsch. But he has

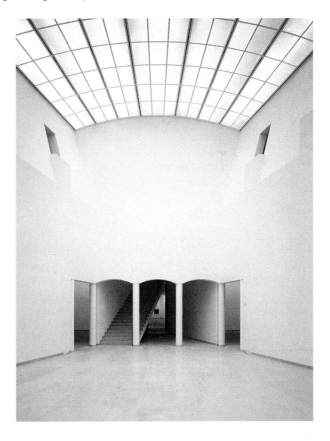

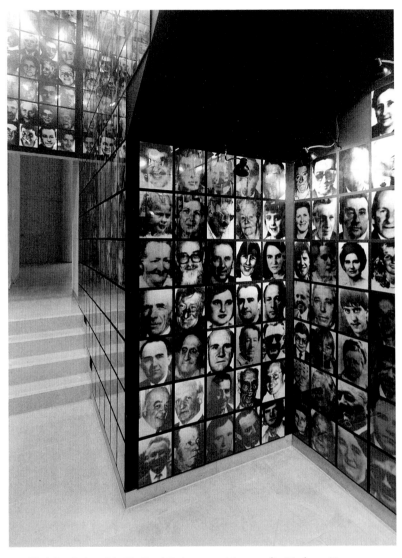

53 Christian Boltanski, *The Dead Swiss*, 1990, Museum für Moderne Kunst, Frankfurt-am-Main

not shied away from interpretation, grouping works and artists which seem to connect with one another in what he terms 'climatic zones', a process comparable with the zones of influence which I have identified at Schaffhausen. In contrast to most other museum curators Ammann does not arrange temporary loan exhibitions. Certain installations and rooms in the museum are permanent. Others change on a periodic basis as works are added to the collection, creating new confrontations and echoes.

One final example may serve as a cautionary reminder that stasis also remains a valuable component of the museum. Permanent installation offers an encounter with a particular work of art within a given space where change is brought about not by new juxtapositions but by the changing natural light at different times of the day and by the changing perspective of the viewer. This was the ideal that drove Donald Judd to

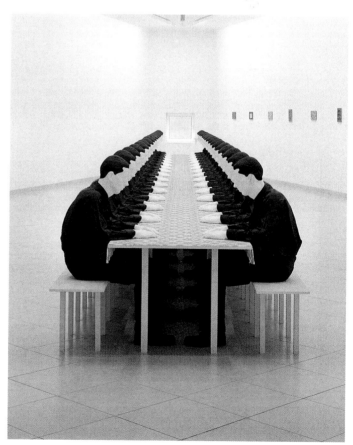

54 Katharina Fritsch, *Tischgesellschaft* (Company at Table), 1988, Museum für Moderne Kunst, Frankfurt-am-Main

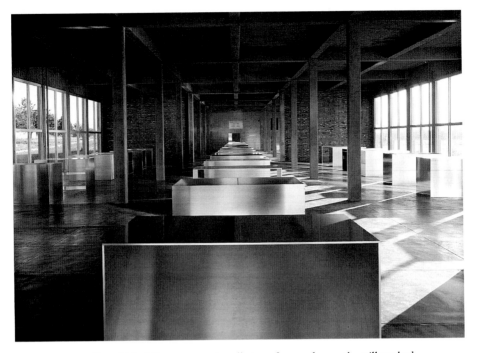

55 Donald Judd's permanent installation of 52 works, north artillery shed, the Chinati Foundation, Marfa, Texas

create a new form of museum at Marfa, Texas in the late 1970s.[46] Judd was critical of the way in which museums display contemporary art in anthologies of short duration. At Marfa he took a range of disused military buildings and with removals of sparing economy and finely judged additions designed by himself, he created space in which to show his own work extensively and the work of others in selected installations. As installations they are exemplary; as an experience of the work they afford a deep and measured view. And from this example lessons have been learned with regard for the need in museums for places of prolonged concentration and contemplation.

However, we have seen how 'experience' can become a formula. The best museums of the future will, like Schaffhausen, Insel Hombroich

and Frankfurt, seek to promote different modes and levels of 'interpretation' by subtle juxtapositions of 'experience'. Some rooms and works will be fixed, the pole star around which others will turn. In this way we can expect to create a matrix of changing relationships to be explored by visitors according to their particular interests and sensibilities. In the new museum, each of us, curators and visitors alike, will have to become more willing to chart our own path, redrawing the map of modern art, rather than following a single path laid down by a curator. We have come a long way from Eastlake's chronological hang by school, but the educational and aesthetic purpose is no less significant. One-artist displays have a part to play, especially in presenting site-specific work and in facilitating concentration, but in my view we still need a curator to stimulate readings of the collection and to establish those 'climatic zones' which can enrich our appreciation and understanding of the art of this century. Our aim must be to generate a condition in which visitors can experience a sense of discovery in looking at particular paintings, sculptures or installations in a particular room at a particular moment, rather than find themselves standing on the conveyor belt of history.

NOTES TO THE TEXT

1 Following the Report of the Parlia‑
mentary Select Committee on the
Management of the National Gallery in
1853, the administration of the Gallery
was reconstituted by Treasury Minute,
dated 27 March 1855, and Eastlake, then
President of the Royal Academy, was
appointed as its first Director. See *National
Gallery Report 1856.*

2 For a full discussion of Eastlake's role as
Director of the National Gallery, see
Giles Waterfield, *Picture Hanging and
Gallery Decoration in Palaces of Art.
Art Galleries in Britain 1790–1990,*
Dulwich Picture Gallery, London 1991,
pp. 53–54. This volume, published to
coincide with the exhibition of the same
title, is an essential and masterly intro‑
duction to a subject which will be more
extensively treated in Waterfield's forth‑
coming study. See also Sir Charles
Holmes and C. H. Collins Baker, *The
Making of the National Gallery 1824–1924,*
The National Gallery, London 1924,
pp. 13–41.

3 Of the eight works by Giovanni Bellini
now in the National Gallery, four were
purchased during Eastlake's periods of
office as Keeper (1843–47) and Director
(1855–65). A further work, now ascribed
to Bellini, was purchased for his own
collection in 1854 and presented in his
memory by Lady Eastlake in 1870.

4 Minutes of the Trustees of the National
Gallery 16 November 1857, as quoted by
Waterfield, *op. cit.,* p. 54.

5 Eastlake in a letter to the Trustees dated
1 May 1845 and cited in a memorandum
from Eastlake to the Trustees dated

1 February 1847, as quoted in Waterfield,
op. cit., p. 93.

6 Thomas Struth's photograph is one in a
series which presents interior views of
museums, including the Kunsthistorisches
Museum, Vienna, the Louvre, Paris,
The National Gallery, London (all
1989), The Art Institute of Chicago
(1991), Gallerie dell'Accademia, Venice
(1992) and The Museum of Modern Art,
New York (1994). Struth's initial interest
in museum interiors had been stimulated
by his interest, as a photographer of people,
in Renaissance portrait conventions.

7 From left to right, the works are
Giovanni Bellini, *The Madonna of the
Meadow* (N599), Cima da Conegliano,
The Incredulity of Saint Thomas, c. 1502–4
(N816) and Giovanni Bellini, *The Doge
Leonardo Loredan, Full Face, c.* 1501
(N189). See Martin Davies, National
Gallery catalogues; *The Earlier Italian
School,* 1961. These works, shown here in
the original Wilkins building, are now
installed in the Sainsbury Wing in a
different arrangement which places the
Cima on axis with the entrance to the
Wing, at the expense of compositional
balance within a room devoted to early
cinquecento Venetian painting.

8 Varnedoe breaks the Museum of Modern
Art's convention that the spectator passes
through each room by allowing only a
single door on axis with the most
magnificent of Pollock's works. Pollock
creates a new kind of non‑perspectival
space which in Varnedoe's compelling
display surrounds and envelops the
visitor.

9 The contrast between the idea of the museum as a place of education or information and the museum as the place in which works of art may be experienced for themselves, detached from their context, is examined by Theodor Adorno in his seminal essay 'Le problème des musées', *Valéry, Proust, Museum*, published in *Prisms*, Cambridge Massachusetts, MIT Press, 1981, pp. 173–85. Valéry criticizes the way in which museums bring together objects of many different types to create confusion in the mind of the spectator by reducing the experience to the level of information only. For Proust, by contrast, the work of art is elevated above the day-to-day by its placing in the museum 'where the rooms, in their sober abstinence from all decorative detail, symbolize the inner spaces into which the artist withdraws to create the work'.

10 It should be observed, however, that Varnedoe himself breaks the first reading of the installation by the subtle introduction of Giacometti's *Standing Woman* (1948). It was this particular sculpture, shown in New York at the Pierre Matisse Gallery in 1948, which encouraged Newman, both in his exploration of the vertical 'zip' in painting and especially in his move into the field of sculpture with *Here I* (1950).

11 For Barr's early formulation of the principles of the museum, see *Defining Modern Art: Selected Writings of Alfred Barr*, eds. Irving Sandler and Amy Newman, New York, Abrams, 1986.

12 Pollock, for instance, was given a full retrospective by the museum only in 1959, three years after his death, while David Smith was shown rarely by the museum and in full only in 1966, the year following his death.

13 See Ronald Alley, *Catalogue of the Tate Gallery's Collection of Modern Art*, The Tate Gallery, London, 1981, p. xvii.

14 Lawrence Gowing, sympathetic observer and former member of staff, was, for instance, positive in his reaction to this initial display of the Collection, but nevertheless recognized the visual 'indigestion'. See Lawrence Gowing, 'The New Tate', *Encounter*, August 1979, reprinted in *The Tate Gallery 1978–80*, The Tate Gallery, London, 1980, pp. 102–4.

15 Furthermore, the installation of the permanent collection by Rubin closed with Abstract Expressionism. Art of the last twenty-five years from 1960 to the present, including Pop and Minimalism, was shown in a rotating display confined to the west wing of the third floor of the museum.

16 For a thorough account of Sandberg's remarkable vision of the museum as an institution engaged in contemporary culture and working with artists, see *Sandberg, a Documentary*, compiled by Ad Petersen and Pieter Brattinga, Kosmos, Amsterdam 1975.

17 Pontus Hulten, *La Centre National d'Art et de Culture Georges Pompidou*, 1977, p. 52.

18 *Paris–New York* 1977, *Paris–Berlin* 1978, *Paris–Moscow* 1979 and *Paris–Paris* 1981.

19 Designed by Gaia Aulenti, in close collaboration with Dominique Bozo, the architecture conforms to the rhythm of the Piano and Rogers building, but masks the ceilings and forsakes infinite flexibility for 'permanent' walls.

20 Museums have often devoted single rooms, or even suites, to the work of one artist where the collection is especially rich in the holding of that artist. Notable examples include the rooms given over to Léger or Picasso at the Kunstmuseum, Basel, or to Giacometti at the Kunsthaus, Zurich. However, dedication of a room to the work of a living artist has been much more rare.

21 For the full collection, see Germano Celant, *Das Bild einer Geschichte 1956/76. Die Sammlung Panza di Biumo*, Kunstsammlung Nordrhein-Westfalen Kunstmuseum und Kunsthalle Düsseldorf and Electa International, 1980, and *Art of the Sixties and Seventies: The Panza Collection*, Rizzoli, New York 1988.

22 Of the works on display, only those by Brancusi and Kandinsky had been long in the collection. Most of the Rymans and Andres had been acquired as part of the Panza Collection in 1990, those by Bourgeois and Beuys in the months leading up to the opening of the new museum.

23 Thomas Krens, *Flash Art International*, edition no. 167, November–December 1992, p. 127.

24 In the same article, Krens goes on to say: 'I have seen how isolated museums can become in their public appreciation because they are bound to their locality and their region.' Of course, a local museum can become parochial, but most of us do not travel across the continents simply to see further examples of familiar names. The most interesting museums of contemporary art use a variety of means to convey a strong sense of place.

25 The Bonn Kunstmuseum is given over exclusively to German art, principally of the post-war period, (with the current exception of one room devoted to Cy Twombly).

26 For details and conditions of the Rothko gift to the Tate Gallery, see Ronald Alley, *Catalogue of the Tate Gallery's Collection of Modern Art*, The Tate Gallery, London 1981, pp. 657–63. For the gift and the *Seagram Murals*, see Michael Compton's introduction in *Mark Rothko: The Seagram Mural Project*, The Tate Gallery, Liverpool 1988, and Thomas Kellein, *Mark Rothko Kaaba in New York*, Kunsthalle, Basel 1989.

For Still's control over his œuvre and estate and the donations to Buffalo and San Francisco, see Thomas Kellein, *Clyfford Still*, Kunsthalle, Basel 1992.

27 For further consideration of Rothko's strategy, see Michael Compton, 'The Big Picture', *tate magazine*, summer 1995, pp. 49–51.

28 One-person exhibitions, now a common-place, were once surprisingly rare. Picasso, for instance, did not receive his first major museum exhibition until the age of fifty. Until the post-war period it was unusual for a living artist to see a survey of his own work, such present-ations usually occurring, as was the case for Cézanne, with a memorial exhibition.

29 For a discussion of *The Red Studio* and other interiors of the same year, see John Elderfield, *Matisse in the Collection of the Museum of Modern Art*, the Museum of Modern Art, New York 1978, pp. 86–89.

30 An intriguing comparison may be made with two well known drawings in pencil

of Giacometti's studio in Paris in 1932; see Reinhold Hohl, 'Alberto Giacometti Atelier im Jahr 1932', *Du*, no. 363, May 1971, pp. 352–65.

31 For the conditions of Brancusi's bequest, see Isabelle Monod-Fontaine, 'Brancusi Scénographe', *Cahiers*, 17/18, 1986, p. 61.

32 Richard Serra, for instance, visited Paris in 1964–65 on a scholarship from Yale and has described one of his two main preoccupations as 'drawing in Brancusi's studio'. He continued: 'What interested me about Brancusi was how he could suggest volume with a line along an edge; in short, the importance of drawing in his sculpture'. *Richard Serra Writings and Interviews*, Chicago 1994, pp. 157–58.

33 See 'Natural Reality and Abstract Reality: A Trialogue (While Strolling from the Country to the City) 1919–20' in *The New Art – The New Life: The Collected Writings of Piet Mondrian*, eds. Harry Holtzman and Martin S. James, Thames and Hudson, London 1986, p. 110.

34 *Ibid.*, p. 242.

35 See Anne d'Harnoncourt, *Marcel Duchamp Manual of Instructions for Étant Donnés*, Philadelphia Museum of Art, 1987.

36 See my introduction in *Carl Andre*, Whitechapel Art Gallery, 1978, n.p.

37 Serra has, for instance, acknowledged the importance of Pollock's *Mural* (1943, University of Iowa), painted for the hall of Peggy Guggenheim's apartment, in the development of the compositional structure of his sculpture *Belts* (1966–67, The Solomon R. Guggenheim Museum, Panza Collection). See Serra, *op. cit.*, pp. 114 and 149.

38 This similarity is most eloquently explored by Rosalind Krauss, in *Richard Serra Sculpture*, The Museum of Modern Art, New York 1986, p. 15.

39 See Serra, *op. cit.*, pp. 271–80.

40 Beuys frequently created 'sculpture' from two-dimensional material, as in the sculpture *Richtkräfte* (1974, Nationalgalerie, Berlin) made from the blackboards used in lectures at the Institute of Contemporary Arts, London, or the installation of drawings from 'The Secret Block', one section of which was shown in 1974 at the Museum of Modern Art, Oxford, laid out on a table 60 feet long specially constructed from scaffold boards and plasterers' trestles.

41 Scott Burton, 'My Brancusi', in *Artist's Choice: Burton on Brancusi*, The Museum of Modern Art, New York 1989, and Joseph Kosuth, *The Play of the Unmentionable*, Joseph Kosuth and David Freedberg, Brooklyn Museum of Art, 1992.

42 See Paul Good, *Hermes or the Philosophy of the Island of Hombroich*, Neuss 1987.

43 See especially Rudi Fuchs, *documenta 7*, Kassel 1982, and *Ouverture*, Castello di Rivoli, Turin 1984.

44 See Philip Peters, 'Back to the Front line! The Stedelijk Museum after five "Couplets"', *Kunst and Museumjournaal*, vol. 6, no. 3/4, 1995, pp. 49–54.

45 Jean-Christophe Ammann, *From the Perspective of My Mind's Eye*, Museum für Moderne Kunst, Frankfurt 1991.

46 See Donald Judd, *Räume/Spaces*, Wiesbaden Museum 1993.

LIST OF ILLUSTRATIONS

Measurements are given in centimetres, followed by inches in brackets. Height precedes width.

1 Giovanni Bellini, *The Madonna of the Meadow*, c. 1505. Transferred from panel, painted surface 67.3 × 86.4 (26½ × 34). Reproduced by courtesy of the Trustees of the National Gallery, London

2 Thomas Struth, *National Gallery 1*, 1989. Cibachrome print 180 × 196 (71 × 77¼). Courtesy Marian Goodman Gallery, New York

3 Thomas Struth, *Museum of Modern Art 1*, 1994. Cibachrome print 180 × 238 (70⅞ × 93⅞). Courtesy Marian Goodman Gallery, New York

4 Ground plan of the Tate Gallery, London, 1979. Photo Tate Gallery, London

5 View of the gallery 'Nicholson, Hepworth, St Ives and British Nature Abstraction', Tate Gallery, London, 1979. Photo Tate Gallery London. © Angela Verren Taunt 1996. All rights reserved DACS. © Alan Bowness, Hepworth Estate

6 Ground plan of the second floor galleries, The Museum of Modern Art, New York. From Information/Plan The Museum of Modern Art, New York, 1984. Offset, printed in black, 10.8 × 27.9 (4¼ × 11). Photograph © 1996 The Museum of Modern Art, New York

7 Max Beckmann, *The Departure*, 1932–33. Oil on canvas, triptych, centre panel 215.3 × 115.2 (84¾ × 45⅜); side panels each 215.3 × 99.7 (84¾ × 39¼). The Museum of Modern Art, New York. Given anonymously (by exchange). Photograph © 1996 The Museum of Modern Art, New York. © DACS 1996

8 View of the exhibition *Paris–New York*, Pompidou Centre, Paris, 1977. Photo Musée National d'Art Moderne, Paris/Jacques Toujour

9 View of the gallery showing late work by Barbara Hepworth, Tate Gallery, London, 1992. Photo Tate Gallery, London. © Alan Bowness, Hepworth Estate

10 View of installation by Dan Flavin, *The Guggenheim Museum and the Art of this Century*, Solomon R. Guggenheim Museum, New York, 1992. Photograph by David Heald. © The Solomon R. Guggenheim Foundation, New York

11 View of a gallery showing work by Gerhard Richter at the Kunstmuseum, Bonn. © Kunstmuseum, Bonn/Reni Hansen

12 View of Marc Rothko's *Seagram Murals*, Tate Gallery, London, 1992. Photo Tate Gallery, London. © ARS, New York and DACS, London 1996

13 View of the exhibition of paintings by Clyfford Still from the collections of The San Francisco Museum of Modern Art and the Albright Knox Museum, Buffalo, January 16–March 7, 1993. Photo T. Loonan

14 Henri Matisse, *The Red Studio*, Issy les Moulineaux 1911. Oil on canvas 181 × 219.1 (71¼ × 86¼). The Museum of Modern Art, New York. Mrs Simon Guggenheim Fund. Photograph © 1996

The Museum of Modern Art, New York. © Succession H. Matisse/DACS 1996

15 Théodore Géricault, *Portrait of an Artist*, c. 1820. Oil on canvas 147 × 114 (57⅞ × 45). Musée du Louvre, Paris

16 Gustave Courbet, *The Artist's Studio*, 1854–55. Oil on canvas 361 × 598 (142⅛ × 235½). Musée d'Orsay, Paris

17 Photograph by Hélène Adant of Matisse's studio at the Hôtel Régina, Nice, showing the artist drawing the Virgin and Child, for the Chapel of the Rosary, Vence, 1950. Photo Musée Matisse, Nice.

18 Photograph by Hélène Adant of Matisse's studio at the Hôtel Régina, Nice, showing *La Piscine*, c. 1952. Photo Musée National d'Art Moderne, Paris.

19 Constantin Brancusi, *View of the Artist's Studio*, 1918. Gouache and pencil on paper 32.8 × 41.1 (13 × 16¼). The Museum of Modern Art, New York. The Joan and Lester Avnet Collection. Photograph © 1996 The Museum of Modern Art, New York. © ADAGP, Paris and DACS, London

20 Photograph by Constantin Brancusi of his studio, showing *Mlle Pogany II*, 1920. Photo Musée National d'Art Moderne, Paris. © ADAGP, Paris and DACS, London

21 Photograph by Constantin Brancusi of his studio, showing an *Endless Column*, c. 1929. © ADAGP, Paris and DACS, London

22 Photograph by Constantin Brancusi of his studio, showing an *Endless Column*, *Fish* and *The Sorceress*, c. 1925. © ADAGP, Paris and DACS, London

23 Photograph by Constantin Brancusi of his studio, showing *King of Kings*, c. 1945–46. © ADAGP, Paris and DACS, London

24 Piet Mondrian's studio in Paris, 1926. Photo Koninklijke Bibliotheek, The Hague

25 Photograph by Harry Holtzman of Piet Mondrian's studio in New York, 1944. © 1996 Mondrian Estate/Holtzman Trust, Essex, Connecticut

26 El Lissitsky, *Proun Room* (1965 reconstruction), 1923. Wood 300 × 300 × 260 (118 × 118 × 102). Municipal van Abbemuseum, Eindhoven. © DACS 1996

27 Kurt Schwitters, *Merzbau*, completed in Hanover 1933. Destroyed. Photo Landesgalerie, Hanover. © DACS 1996

28, 29 Marcel Duchamp, *Etant donnés: The Waterfall* and *The Illuminating Gas*, 1946–66. Mixed media assemblage: an old wooden door, bricks, velvet, wood, leather stretched over a metal armature, twigs, aluminium, iron, glass, plexiglass, linoleum, cotton, electric lamps, gas lamp (Bec Auer type), motor 242.5 × 117.8 × 124.5 (95½ × 46⅜ × 49). Philadelphia Museum of Art. Gift of the Cassandra Foundation, 1969. © ADAGP, Paris and DACS, London 1996

30 Carl Andre, *Lever*, 1966. Firebrick (137-unit line) each 6.4 × 11.4 × 22.5 (2½ × 4½ × 8⅞), overall 11.4 × 22.5 × 885.2 (4½ × 8⅞ × 348½). The National Gallery of Canada, Ottawa

31 Carl Andre, *Seventeenth Copper Cardinal*, 1977. Copper (17-unit line) each 0.5 × 49.9 × 49.9 (¼ × 19⅝ × 19⅝), overall 0.5 × 849.6 × 49.9 (¼ × 334½ × 19⅝). Private

collection, Pennsylvania. Photo courtesy Paula Cooper Gallery, New York

32 Carl Andre, *Eight Cuts*, 1967. Concrete block capstones in 1472-unit rectangle with eight 30-unit rectangular voids; approx. 5 × 20.3 × 40.6 (2 × 8 × 16) each, approx. 5 × 680.7 × 1300.5 (2 × 268 × 512) overall. Collection Raussmüller, Switzerland. Photo courtesy Paula Cooper Gallery, New York

33 Photograph by Hans Namuth of Jackson Pollock painting in his studio, East Hampton, Long Island, *c.* 1950

34 Photograph by Gianfranco Gorgoni of Richard Serra throwing lead, Castelli Warehouse, New York, 1969

35 Richard Serra, *Splashing*, 1968. Lead 45.7 × 66 (18 × 26). Installed Castelli Warehouse, New York 1968. Destroyed

36 Richard Serra, *Circuit*, 1972. Hot-rolled steel. Four plates, each 244 × 731.5 × 2.5 (96 × 288 × 1); 244 × 1097 × 1097 (96 × 432 × 432) overall. Temporary site-specific installation at *documenta 5*, Kassel, 1972

37 Richard Serra, *Weight and Measure*, 1992. Forged steel, 2 blocks: 173 × 104 × 275 (68 × 41 × 108½) and 152 × 104 × 275 (60 × 41 × 108½). Installed at the Tate Gallery, London 1992. Photo Stefan Erfurt, Wuppertal

38 View of Marcel Broodthaers's exhibition *Section of Figures (the Eagle from the Oligocene to the Present)*, Kunsthalle, Düsseldorf, 1972. Photo Maria Gilissen

39 Detail from Marcel Broodthaers's exhibition *Section of Figures (the Eagle from the Oligocene to the Present)*, Kunsthalle, Düsseldorf, 1972. Photo Maria Gilissen

40 Room 1, Beuys Block, Hessisches Landesmuseum, Darmstadt. Photo Claudio Abate. Block Beuys © Schirmer/Mosel Verlag, Munich. © DACS 1996

41 Room 3, Beuys Block, Hessisches Landesmuseum, Darmstadt. Photo Claudio Abate. Block Beuys © Schirmer/Mosel Verlag, Munich. © DACS 1996

42 Room 5, Beuys Block, Hessisches Landesmuseum, Darmstadt. Photo Claudio Abate. Block Beuys © Schirmer/Mosel Verlag, Munich. © DACS 1996

43 Room 2, Beuys Block, Hessisches Landesmuseum, Darmstadt. Photo Claudio Abate. Block Beuys © Schirmer/Mosel Verlag, Munich. © DACS 1996

44 View of three works by Bruce Nauman. Hallen für Neue Kunst, Schaffhausen, Switzerland. © ARS, New York and DACS, London 1996

45 Joseph Beuys, *Das Kapital Room*, 1970–77. Hallen für Neue Kunst, Schaffhausen, Switzerland. © DACS 1996

46 View of gallery with Carl Andre's *Thirty-Seven Pieces of Work* (left) and *Sum 13* (right) with paintings by Robert Ryman. Hallen für Neue Kunst, Schaffhausen, Switzerland

47 View of Insel Hombroich, Neuss, Germany. Photo © Tomas Riehle

48 View of Insel Hombroich, with sculpture by Marc di Suvero, Neuss, Germany. Photo © Tomas Riehle

49 Ground plan of the pavilions of Insel Hombroich, Neuss, Germany. Courtesy Erwin Heerich

50 View of the gallery with Khmer sculptures and paintings by Gotthard

Graubner, Insel Hombroich, Neuss, Germany. Photo © Tomas Riehle

51 Ground plan of the first floor of the Museum für Moderne Kunst, Frankfurt-am-Main

52 View of the central room, Museum für Moderne Kunst, Frankfurt-am-Main. Photo Rudolf Nagel

53 Christian Boltanski, *The Dead Swiss*, 1990. 754 black and white photographs, each 30.5 × 24 (12 × 9½). Museum für Moderne Kunst, Frankfurt-am-Main. Photo Rudolf Nagel. © ADAGP, Paris and DACS, London 1996

54 Katharina Fritsch, *Tischgesellschaft* (Company at Table), 1988. 32 polyester figures, cotton clothes and table cloth, wooden table and benches 140 × 1600 × 175 (55⅛ × 630 × 69). Museum für Moderne Kunst, Frankfurt-am-Main. Photo Axel Schneider. © DACS 1996

55 Donald Judd's permanent installation of mill aluminum works, north artillery shed, The Chinati Foundation, Marfa, Texas. Photo by Todd Eberle. © Estate of Donald Judd/DACS, London/ VAGA, New York 1996